My favorite type of pet has always been a dog. They're loyal, kind, and offer endless affection. My friend Eric says, 'The more people I meet, the more I like my dog.' Funny thought.

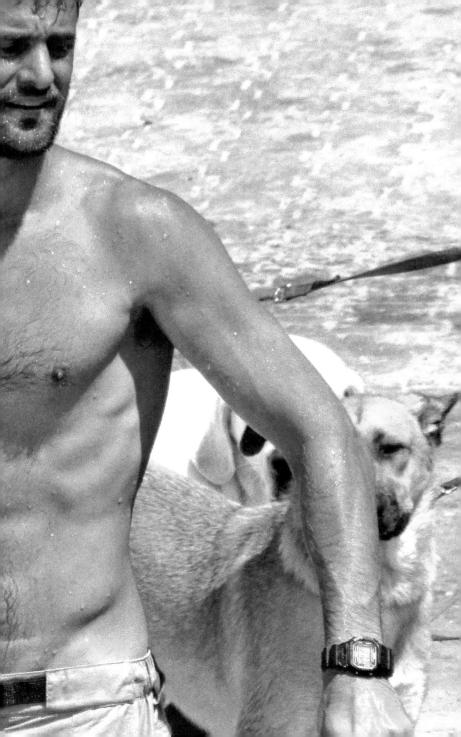

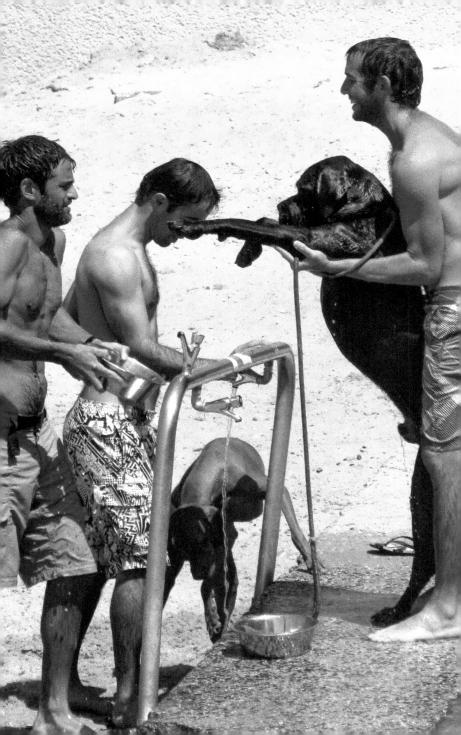

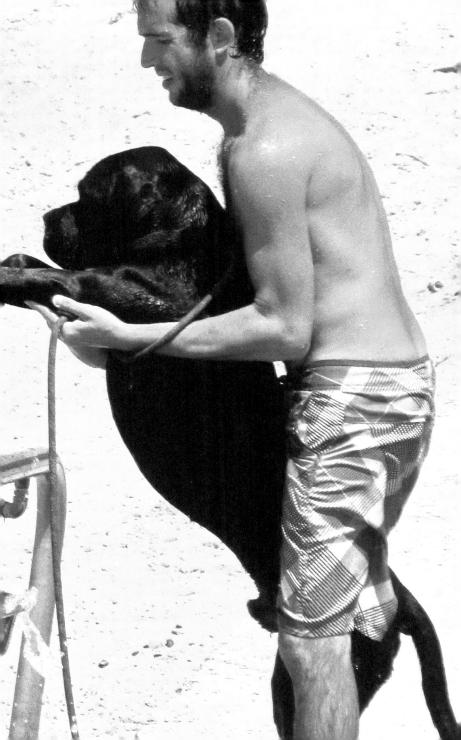

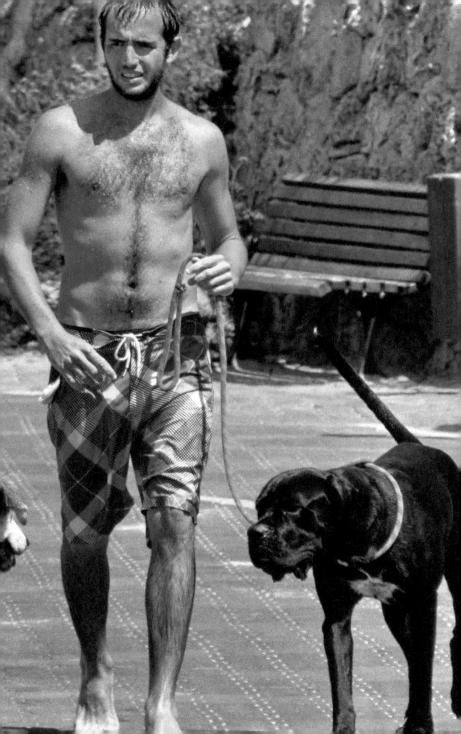